RITA WOLFF

WATERCOLOURS

ACADEMY EDITIONS · LONDON

RITA WOLFF

WATERCOLOURS

1974 – 1985

MCMLXXXVI

ESSAY BY MAURICE CULOT

INTRODUCTION BY DEMETRI PORPHYRIOS

ST. MARTIN'S PRESS · NEW YORK

Thanks to Alan Colquhoun, Michèle Osborne, Bernard Neis, Andrew and Alexandra von Preussen for their kind permission to reproduce the paintings in their possession.
I am indebted to Dr Andreas Papadakis and the staff at Academy Editions, especially to Frank Russell and Pamela Johnston.
My warmest gratitude to Demetri Porphyrios for his support and sympathy, to Maurice Culot, who championed the idea for this compendium, for his unfailing help, and finally to Leon Krier for his constant encouragement, criticism and inspiration.

Concept and design by Leon Krier

* *

*

First published in Great Britain in 1986 by
Academy Editions, 7/8 Holland Street, London W8

ISBN 0 85670 878 X cl
ISBN 0 85670 879 8 pb

Published in the United States of America in 1986 by
St. Martin's Press, 175 Fifth Avenue, New York, NY 10010

ISBN 0 312 68463 0 cl
ISBN 0 312 68464 9 pb

Printed and bound in Hong Kong

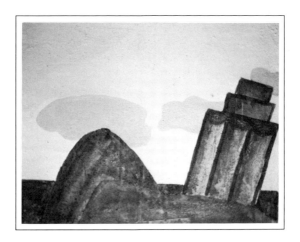

INTRODUCTION

Demetri Porphyrios

IN RECENT YEARS, A HISTORICIST FASHION HAS SPREAD IN PAINTING.
Painters have sought to revive a long-forgotten humanism that is meant to
exorcise the aggressive exercises of their predecessors in the 1960s. But in their
hurried zeal, these recent historicist painters have only managed to sandwich
classical humanism between thick layers of inflated allegories. The 1984 Venice
Biennale confirms this view: grandiloquent themes with pastiche images from
antiquity and radiant ersatz colours are symptoms of an already tired taste.

This general mediocrity of recent historicist painting partly reflects our
contemporary predicament: we have all the myths of the world available to
ourselves but none can impose itself as our own by simple right of inheritance. And

while previously man was part of a total encompassing world, now life is permeated by a sense of homelessness.

It is this 'fallen' world that Rita Wolff grieves in her paintings. Her inspiration is inner melancholy about the hollowed-out myths of contemporary life. The emphasis is always on mood rather than spectacle between the glory that was painting and the sad reality it has become. But while this inner grief and disillusionment runs throughout as an unspoken refrain, it is never allowed to become nihilistic and sombre. Wolff tells us that her paintings are renditions of dreams her friends have confided to her. Her paintings-dreams, therefore, if we are to believe Freud, 'must beware of being intelligible, for else [they] would be destroyed; [they] can only exist in disguise.'

Not surprisingly, therefore, Rita Wolff will turn her back on the vaunted erudition of historicist painting in order to return to the world of the unconscious where cherished memories and future possibilities intersect. This is the world of symbolism: a world marked by the refinement and concentration of romantic experience. Wolff is haunted by the sound of objects and of our own inarticulate thoughts about the drama of a world that has vanished. Yet her paintings do not suffer from nihilistic despair for she reaches out from her solitude and looks at the world as '. . . a kind of nourishment that the imagination must digest and transform.'

When we look at Wolff's paintings, our eyes wander restlessly over the painted surface in an effort to decipher the meaning of the objects presented as well as the significant omissions and silences which structure the painting. But we can find no rest and no finality. Unexpected juxtapositions decentralise the 'normality' of the objects presented, challenging rather than anticipating a resolution. In fact, the compositional devices Wolff uses are characteristic to the language of symbolism that Jean Moréas had described in the symbolist manifesto of 1886: '. . . significant pleonasms, mysterious ellipses, suspended anacoluthon . . .'

The other preoccupation of symbolism, that with sensuousness, is also present in Rita Wolff's paintings. The sensuous dimension of nostalgia is painted in clusters of imagery: the breeze of the sea, the deep perspective of renaissance landscapes, the redolence of air, rich colours and the familiar domesticity of traditional building materials. The *Sunken Landscape* or *Pliny's Villa* are pungent with the fragrance of Italian renaissance landscapes. The heavily perfumed air of *Cairo* bridges the historical gap between the monuments of Dynastic and Muslim Egypt. The nocturnal mystery of *Bremen* imparts on a future cityscape the nostalgic patina of a long-vanished civilisation.

The symbolist preoccupation with sensuousness is also evident in the way Wolff uses colour. The red or turquoise-blue of a flapping curtain – as in *Kenneth's Dream* and *Nocturne at the Market* – is no necessary concomitant of the subject painted. In fact, it is the arbitrariness of the colour chosen that gives the curtain (and by

extension the painting) its glamour. The curtain becomes a 'machine' for colour, soaking our imagination and prompting it to leap the barriers of time and place.

On the other hand, the blue of the sky and sea as well as the green and brown of the landscape in paintings such as *Patmos Square*, *Italian Landscape* or *Leon's Dream* are integral ingredients of experiential reality which add up to 'landscape'. The ochre of walls in *Luxembourg* or *Filadelfia* are decors of reassurance that the world still looks much as it did in the lifetime of our forefathers.

As regards the technique of her painting, Wolff invariably uses a miniature execution, in which the brushstrokes give a sense of cross-hatching. Colour, tone or modulation of light are achieved by superimposing patiently layer after layer of imperceptible miniature brushstrokes. This gives emphasis to the forms while the strong colour aids the sense of a hard-edge composition. And while the perspectival expression gives assurance, the unexpected 'mistakes' in scalar diminution, source of light, casting of shadows or lack of atmospheric perspective introduce a disquieting anxiety and a sense of magic which, presumably, portends some apocalyptic apparition that, nonetheless, will never take place. The effect is rather like that of renaissance predella panels: small, organised in simple, primitivist compositions in bright hues and with a considerable sense of the monumental.

The paintings of Rita Wolff extend, therefore, far beyond the realism of a place and a time. They are a symbolist quest for the reality of an authoritative world and a search for the artistic means for its reconstruction. They show us a world that oscillates between compassion and melancholy. And Rita Wolff paints this world as part of her lifelong preoccupation with finding something 'which cannot be spoiled' and can bridge the ironical distance between past and present.

* *
*

PEINTRE DE RÊVE

Maurice Culot

Dream: sequence of psychological phenomena occurring during sleep (images, representations, automatic, generally involuntary, activity).

Rita Wolff: dream painter, active in the second half of the twentieth century.

Rite: practice, custom, (Latin: ritus), rites of initiation, funerary rites, magic rites, secret rites.

IN FRANCE, AT THE TURN OF THE CENTURY, TWO THINGS PLAYED A large part in speeding up the development of a bad artistic conscience among the bourgeoisie; first, the opposition to the Eiffel Tower, and second, the indifference to Impressionism. When taking stock a short time later, the bourgeoisie noticed that it had committed a grave error of appreciation: by being inattentive to even the most obvious signs of change in society, it had also missed the boat when speculating in modern art.

Fortunately, the well-bred members of this dynamic social class rarely fail to learn a lesson: they will take care, in future, to put the prejudices of their class to one side when judging art. For the artists it is a different story, for they were to be absorbed, either willingly or by force, into their era. While this century did not see the birth of mass anti-conformism, it has seen it enter a phase of official recognition. Originality is no longer condemned, but the artist now has to cover all the common ground, express even the trivialities of the present. Artists have been informed that they are effectively free to give expression to their era without any constraint whatsoever, provided that they express it. Now a creator of plastic form, the artist

trades in his cravatte or his curse – depending on the circumstances – for the blue jeans of the mercenary.

By nature, by conviction, of her own free will, Rita Wolff demonstrates towards her century the same reserve which imparts dignity and authority to the monuments of her art. Her attitude is one which is readily labelled conservative; but what futile resistance can a painter put up against the hugely powerful forces of abstraction and oblivion? The intuition, freshness and spontaneity which worked miracles in the past are today at best enough for a sketch, a drawing, a few canvases, but not a life's work.

The advice which Jacques Chardonne once gave to a young writer – *'One has to tread the earth lightly'* – Rita Wolff has made her own. But did I not tell you? Rita Wolff is a dream painter.

In an empirical universe, the language which allows one to communicate is not necessarily suited to expressing what it is agreed to call 'reality'. Therefore philosophy – and also poetry, music and painting – have to struggle to prevent language capturing and taking over understanding; in the same way, the dream constitutes a rampart, a sort of invisible parapet which protects us from the siren-call of the libido and leads us towards the subconscious (that is, providing it isn't merely what we despise during the day getting its own back on us at night). To those who evoke it, the past gives a sensation of continuity. But this sensation is vague, and it has to be taken whatever way it comes, because if you want to bring the image into focus and make it clear, if you try desperately to tie back together again the broken strands of a memory, you risk losing your way in the quagmire of nostalgia or wandering aimlessly through the subterranean passages of obsession.

Like the past, the dream is composed of fragments which the sleeper attempts, once woken – and still full of wonder at this parallel existence – to reassemble into a story with a beginning and an end. But the dream painter – who must not be confused with the one who paints what is mad, infantile, or bizarre – cannot make do with these *a posteriori* architectures: it is her job to reconstruct the essence of the dream, which comes to her as a story, an account – dry, inert, lifeless material. It is up to her to re-establish the pose, the instant of the picture, the alignment, without dressing up or freezing the anecdote and the fragment. The dream has to be seized in its entirety: in the act of being collected by the painter from benevolent friends, it passes from the state of a dream to that of a narrative, thus the artist's first task is to bring it back to an initial state which is plausible and conceptually satisfying.

Rita knows about the science of secret affinities which bind certain images, she is aware of the mechanism which makes it possible to obtain curious, rare images, but she also knows how unreliable these can turn out to be, and that the painter's art is tied to his capacity to eliminate what is arbitrary and accidental. René Magritte made no secret of the methods he used. To begin with, he painted a door which opened onto a landscape. Next the landscape was represented on the door. Then

Magritte said: let us try something less arbitrary, and next to the door let us make a hole in the wall which is also a door. Let us refine this encounter further by reducing the two objects to one single one. The hole is placed in the door and through this hole can be seen the darkness in which the room is plunged. The image is made richer if one then throws light on the invisible thing which is hidden by the darkness, because we are never satisfied until we can at last see the object, which is the very reason for our existence.

I confess here to having lacked a certain curiosity about the methods Rita Wolff uses to achieve her alchemical synthesis of dreams. Right now the important thing is to divert the attention of the onlooker from the material, the technique, the medium, the frame, the detail – everything – to have him answer an invitation to travel in time and space.

In the middle of the sixteenth century, François de Beaumont (1513-1586), the Baron des Adrets, wreaked havoc in the Midi region of France, sometimes on behalf of the Protestants, sometimes on behalf of the Catholics, reserving a horrible fate for his prisoners. Imagine the scene: from his position on a battlement of his castle, the Baron orders an orchestra to start playing on top of a tower from which the balustrades have been removed. Dancing couples with blindfolded eyes – his prisoners – begin to turn, unaware of the danger, and it is not long before they make the fatal step which sends them plunging down and down until they impale themselves on stakes driven into the ground. The elapse of time erases the conscious memory of physical torture. The horrible suffering of the torture victim in the Middle Ages, the massacre of Jews in the recent past, the savageness of wars today – everything except the immortal martyrdom of Christ and the saints (I'm speaking from my own platform now) – are just abstractions in our eyes. It requires a superhuman effort to imprint on our human flesh the living memory of pain, and with time the artist too becomes the interpreter of the suffering and thus makes it the object of our curiosity, something too distant for us to feel compassion.

The passing years give an aesthetic gloss to the cruelty and sadistic ecstacy of the monster, a prerogative of the rake who still has some spirit while all that the actor has left is his body. De Beaumont was the inventor of a metaphysical ballet: the mute music of the orchestra, the silent waltz of the couples locked into the dance, the fall or the impalement. In the foreground, the Baron des Adrets, combining the roles of director, patron, connoisseur and artist. His art, however, belongs to the past (or, say pessimists, of whom I am one, to the future); posterity is aware of it because of its refinement in evil, its ability to entrance the painter, but this awareness is achieved at the cost of exclusion, of an estrangement which precludes imitation. Rita Wolff, dream painter, presents a world which is admittedly unusual, but her world is one where physical suffering is absent, or better still, unknown. That being so, she takes extra care in case the dreams, suddenly relieved of their weight of blood,

should slip away like the subtle essence of a perfume, an alcohol. And that is where part of her talent lies. Right now, at the very instant I am writing these lines, she is in the large room which overlooks the garden, working on painting a tower without balustrades, at the top of which, on chequered marble tiles, waltzers are turning, their eyes blindfolded, to an orchestra in one of the demilunes, all that is left when the square is inscribed within the circle. The scene is viewed from a levitating room; in the foreground, a silhouette, a man seen from behind, another Baron des Adrets?

Melancholy . . . Happy lives are like so many lost secrets. But later, a long time afterwards (tomorrow perhaps?), one sees that Rita Wolff is applying herself rather painstakingly to the task of drafting a *liber veritatis* unintelligible to speakers of the common tongue, indecipherable by methods of mass determinism – a work which is one of those enigmatic outcries that precede the revolution of the times. The crowned mountain, an analogical substitute for the tower, is a recurrent theme in her pictorial interpretation of dreams. The castle up high, the observatory, the spheres of expectation, the columns which take flight on their own or in flocks, whole buildings, like the *Château des Pyrénées*, leave the ground. Rita Wolff sets in motion a process of levitation and wandering that any psychiatrist would be sure to call erotomaniac; a game of forfeits played by the amorous sleeper racked by the rushes of desire and tenderness which have built up during the day and which are discharged in an alternating sequence of Italian skies and American nights, in those 'phallustrade' evenings already observed by Max Ernst.

Rita Wolff, heroine of the starlit darkness, applies dream treatments to the rare collection she has built up, to Hugo's *L'Aquarium de la nuit*, for example, where the automatic images, hallucinations and fantasies evolve: she finds fugitive images that she intertwines, resurgent dreams that take the same broken path as the knight on some invisible chessboard, successions of fragments waiting for someone to master them; she paints displaced rooms in the air that are visited by swimmers in diving suits and levitating mummies that are tied down only by their bandages, at the mercy of the faintest puff of wind. The future archaeologist's critical work will be arduous and his interpretations contradictory. Did Rita Wolff intend to capture outdated charms, make snapshots of a time of optimism, of builders of worlds; or was she busy, like a transcriber monk, drawing up a derisory and broken survey of a lost continent? Will the aesthete see in a retrospective of her work an increasing awareness of a poetic productivity that was inexhaustible and not dependent on its source, the human dream? Master of her chosen landscape – her daydreams go back to the type of landscape where the figures and the follies, the creatures and the buildings are secondary – Rita observes the dream, as Claude did nature, in order to transform it by applying to it an ideal sense of beauty. This is a beauty whose spectre appears only to those who voluntarily confuse the notions of *wanting* to do and *being able* to do – to Rita who takes upon herself the altruistic task of fusing dreams with a

personal antiquity made of fortresses, solid houses, high walls, sun-scorched piazzas, obvious monuments, but also silent factories, deserted encampments, broken aeroplanes, serpentine rivers . . . a fusion which leads to the creation of an elegiac universe, a cartography for solitary travellers.

De Beaumont's stimulating cruelty is countered by Rita Wolff's persistent gentleness, a trait revealed by the postcards she sends from a parallel world which could well contain the idea of a universe of the soul. Rita, in her flying suit, risks her life. Caught with her hand in the dream, we see her punished, chained to the top of the tower without balustrades, her head thrown back, her body arched in reverse. Here both the expert and the humanist will pick up on her look, which is as gentle and as tender as a smile. Hanging up above, silent, is a column, dislocated like a word broken down into single letters. It spells out: base, shaft, capital. (Unless – the following image – the mummy of a cat is shown going back to its planet.) Like the painting of her elders – Chirico, Magritte or Delvaux – her painting is the object of surveillance; sentinels, guards and witnesses are there to prevent us moving, because if we make one move out of place, the picture will fasten itself onto us, the dream will come undone, and its different spectral forms will begin to witness the spectacle of our life.

Is Rita then a prophetic dream-romancer, an adept of theophilanthropy? No, she is like you and me, a painter who from her London apartment offers those with clear sight little paintings which, besides their decorative value, participate in a kind of Theophany, announcing and guaranteeing the event – the eternal return. Rita Wolff, just like a poet, composes by association of ideas, and her metaphors are the expression of this irrational activity, of this contamination of symbols and forms; ex-voto intended to keep presumptuous reason and exclusive science at bay. After 5,000 years, 150 generations, 'man', and I quote Louis Hautecoeur, 'remains the captive of the magic circle of his prejudices, his cruelties, his infantile terrors, and on the altars of new idols he never ceases, his sacrifices becoming bloodier all the time, to amass victims.'

Is this then a portrait of Rita Wolff as an exorcist? No, she's not that either. What she asks of us, with varying force depending on whether one enjoys her art immensely or only moderately, is to take strength from the poetry of myths, from a cosmic order which is inseparable from its echo, the microcosm of man. The most simple form of the imagination – the dream – is the proper vehicle with which to establish communication between the immensity of space and the being of flesh and blood that is man, since the spectacle of the dream is controlled by a commonplace mechanism, the virtual image only appearing under the prevailing influence of some inferior organ.

The founding gesture is guided by the intention to communicate, to transmit beyond one's self and the consciousness of one's mortality one's hopes in the order of

the world – today as yesterday. The very first towns and colonies had a hole, a ditch where offerings and a handful of earth brought from the mother country were thrown – a *mundus* which established communication with the divinities under the ground. Unconsciously, the dream painter realises the mutuality of this secular rite of attachment to the fertile earth and our innate aspiration towards the celestial vault (what the nomads call the 'tent of the sky', the cupola pricked with stars where the dead reside), an aspiration towards these images which speak to the human imagination but can hardly temper the terrible facts of a universe in constant expansion and of the unalterable, henceforth unequivocal solitude of man – unique and alone in his galaxy. Her paintings are like throws of minuscule dice in a game where the good spirits, those who are quick to see the difference between things, are confronting the superficial spirits, to use Malebranche's classification, those who are inclined towards symbolism, who imagine and presuppose a resemblance between things.

One after another, Rita Wolff's pictures sound the apostolic bell whose ringing, like that of Hagia Sophia in Constantinople long ago, wards off the disorder created by the demons of the night. But those who yesterday believed in the existence of what was unreal are today deaf to hermeticism and no longer even curious about the secrets of the initiated. Dreamers (I would say 'believers', if I weren't afraid of being misunderstood), those who still feel the power of images and architectural forms, are invited by Rita Wolff to make a voyage. She opens windows onto landscapes which do not exist but are nevertheless familiar to us; in that way she catches the demons of the daytime off their guard and goes before us on the perilous path of eternal return. No Christ sitting in judgment to the East, but man as judge of himself in the centre of the cosmos, alone with his works.

Have myths really lost all their power to provide the cultural foundations of the world which is ours? Have they become so hollow that they can no longer even make a semblance of giving some order to the chaos, of timidly warding off the disorder, of taming a nature that is prey to mutants? And what if there were, somewhere in between the global mythology of the ancients and the proliferation of the personal, scattered, fragmentary legends of artist-orphans, some secret passages, some gossamer paths? And what if, in the collective subconscious, in that place of ectoplasmic confusion in men and things, the winds still continued to blow – delightful trade winds and appalling tempests – ready to carry off skiffs and frail flying machines. And what if, once the voyage had begun, getting to the shore was then up to chance and fitness? That's the risk Rita Wolff takes. Who hasn't seen the dream painter, accompanied by a golem modelled out of the debris of dreams (and perhaps with the half-human face of a white rabbit) disappear into that part of the world where the familiar laws of space, time and language no longer hold? Like Alice, her confidence is naive and unshakeable, but contrary to her sister, all Rita

has to do in order to return to reality is close her eyes.

It should already be clear to everyone that this painter's work is not entered in any competition, that it defies stylistic categorisation and, even if the painter of the pictures sometimes admires and imitates the venerated masterpieces – those said with pride to have been baptised with the blood of men – she would never compare her work directly with them.

Rita Wolff is what she is, but if you were forced to assign her some elevated goal, this could only be a desire for beauty in peace. Her taste is definitely for the fragile, and in order to be certain of treading still more lightly on the ground, she has chosen the most ethereal of materials: the dream. Is Rita Wolff a narcissist then? A little, a lot, not at all . . . she knows that today even more than ever it would be vain to try to conquer the difficulties of rational ordering by means of the dream and its representation. Rita paints in the manner of a guide, like a friend for anyone who is willing to accompany her for a moment, without reservation, on a journey, a quest for contact with Being which can only be equalled in the strength of its desire by the eroticism of lovers.

For Rita's art does not lend itself to the game of 'I like this' and 'I don't like that' enjoyed so much by those who feel the constant need to draw up their own limits, prisons in which it is better not to find oneself. The thinking modern artist, sure of himself, a seasoned campaigner, has to meet his destiny in the form of the most unpredictable of obstacles: the temptation to commit suicide. Tormented, made feverish by doubt on the dangerous path which he has nevertheless travelled so many times before, being led from what was *pure necessity* to what was *beautiful* and from there to the *outrageous* and the *excessive*. The artist has outstepped the bounds of the kingdom of which he was master. But he will have to go back one day, for absolute thirst does not remedy nostalgic longing. Then one looks for the ferrymen. Rita Wolff is one of those who point out the rare passages, the fissures, those places one can infiltrate with the hope in one's head that the civilisation which is still ours can once again theorise what is its highest expression, the only one which justifies our aspirations under the dead regard of the stars.

I promised myself, the very moment when Rita proposed that I write a short introduction to the catalogue of her work, to be vigilant, not to lapse into lyricism, a failing of a number of us who have grown up in regions where industry dictates every law right down to the gestures of everyday life. Having reached my deadline, I am forced to admit that I have failed, and there'll be more than one who'll pick up on the immoderateness of my words compared with the unpretentious simplicity of these small paintings, these light watercolours. It is, you see, that it is difficult for an *amateur* (meaning one who loves without having the qualities and knowledge of a connoisseur) to manoeuvre a profound attraction of the mind (and the heart), that mover of mountains.

PLATES

I

DESERTED TOWN

· 220 X 255 MM ·

1980

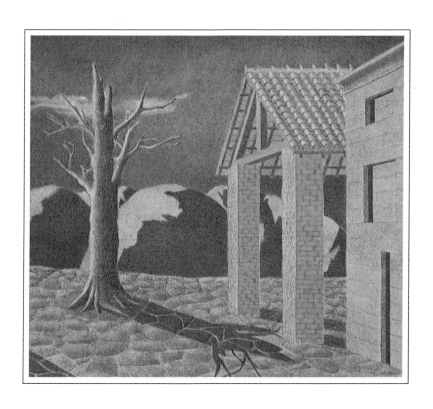

II

ITALIAN LANDSCAPE

· 260 x 230 MM ·

1 9 8 4 - 8 5

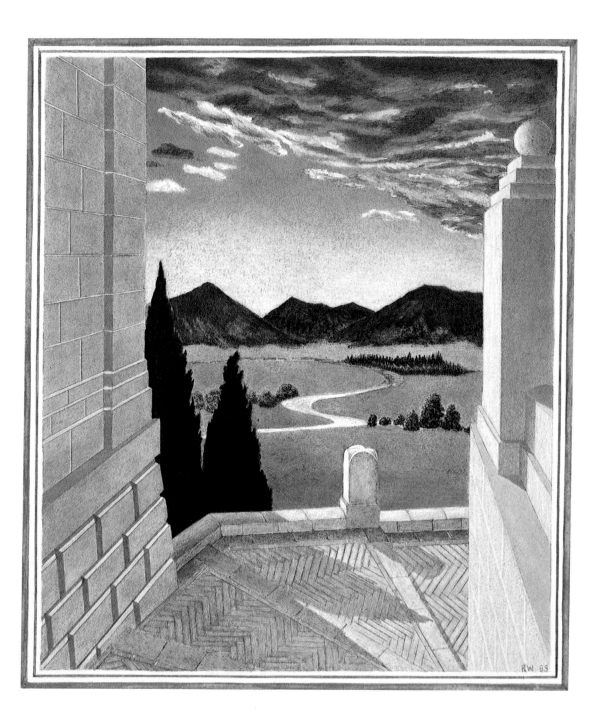

III

FIRST NIGHT IN PRINCETON

· 130 x 190 MM ·

1979

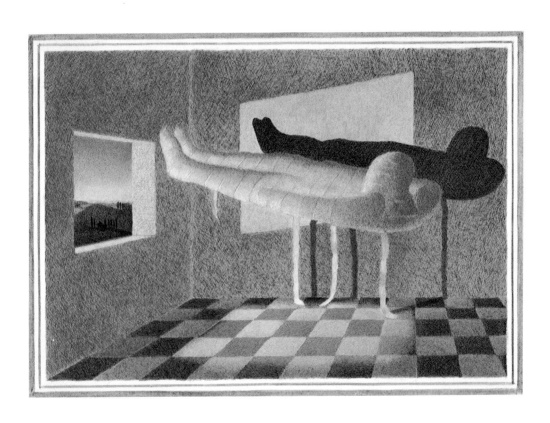

IV

GRAND TOUR 1990

· 260 x 210 MM·

1981

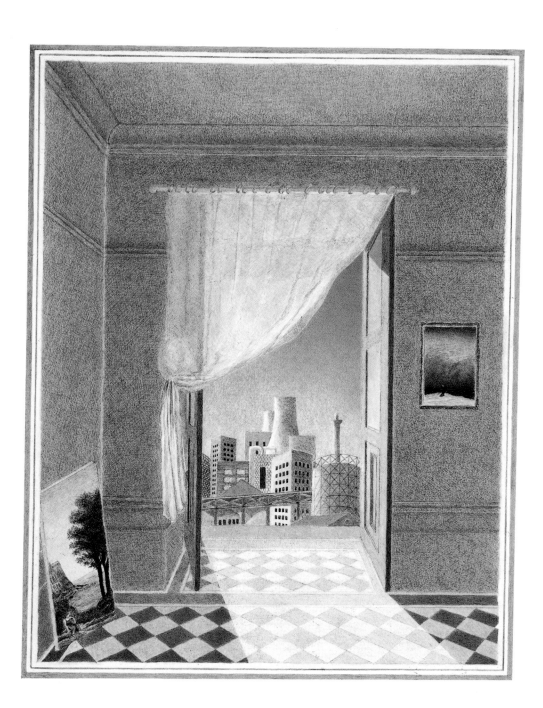

V

L'UTILITÉ PUBLIQUE

· 175 x 125 MM ·

1977

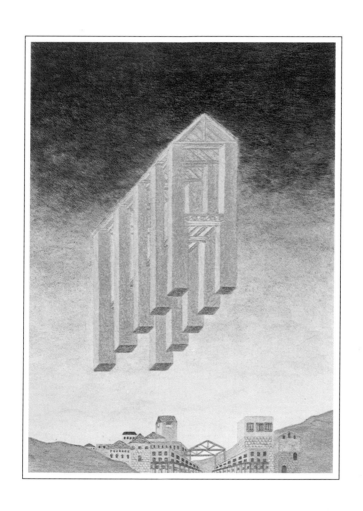

VI

PLINY'S VILLA LAURENTINA

· 285 x 335 MM ·

1982

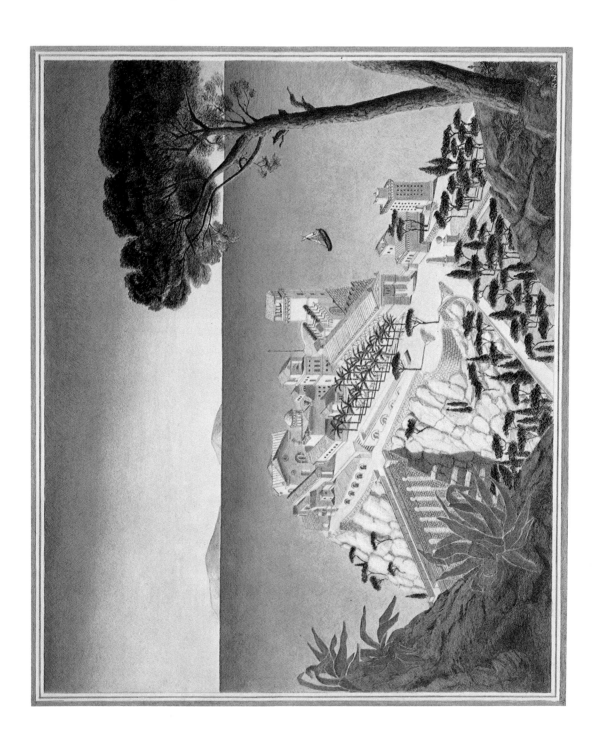

VII

DREAM IN SPERLONGA

· 110 x 130 MM ·

1976

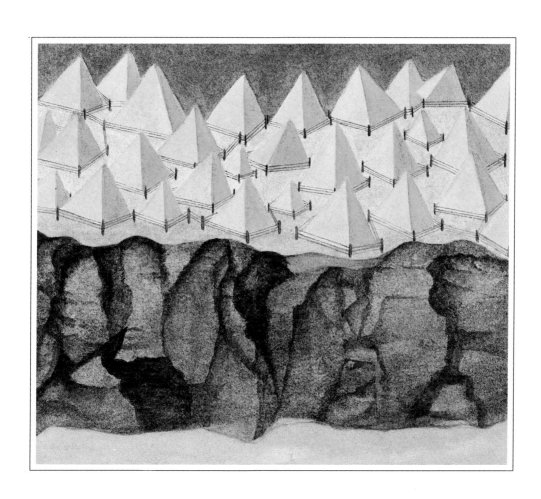

VIII

THE LOST SQUADRON

· 250 x 200 MM ·

1981

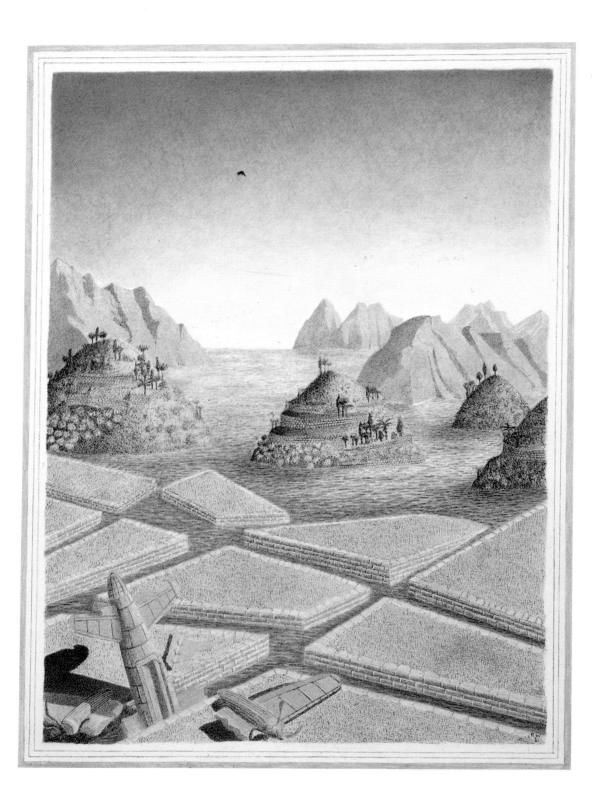

IX

DREAM IN ATHENS

· 255 x 170 MM ·

1980

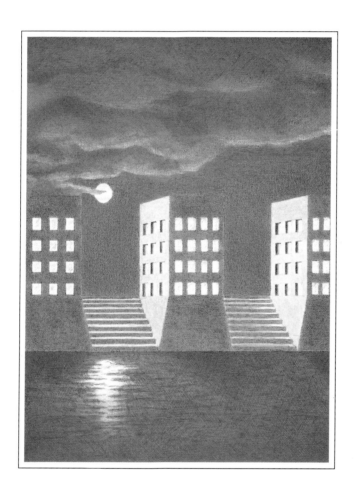

X

THREATENED CITY

· 200 x 170 MM ·

1978

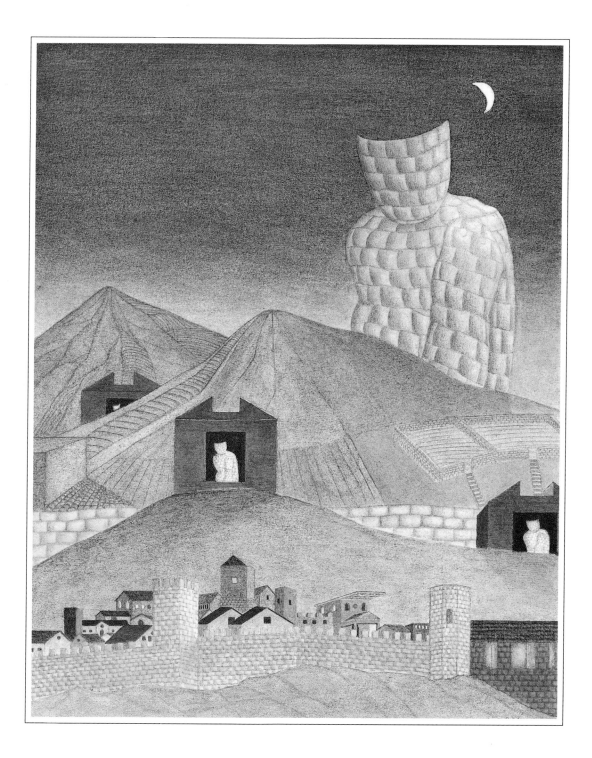

XI

EARLY MORNING HOURS

· 170 x 230 MM ·

1 9 7 7

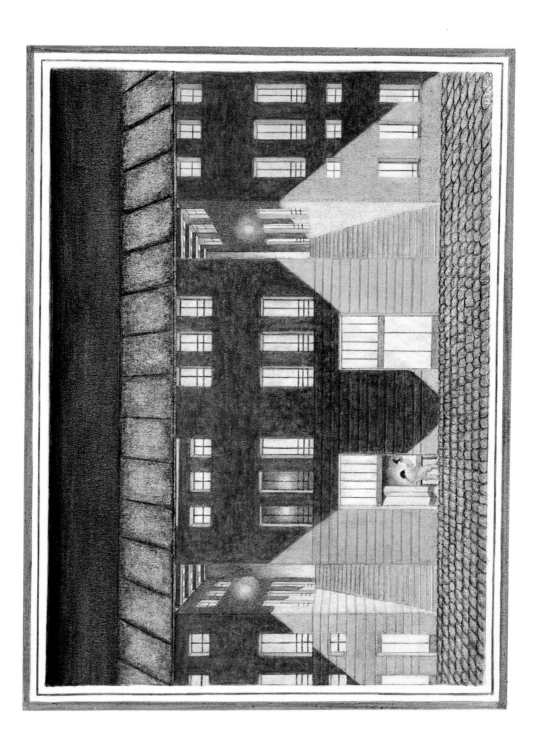

XII

SQUARE IN PATMOS

· 200 x 260 MM ·

1 9 7 9

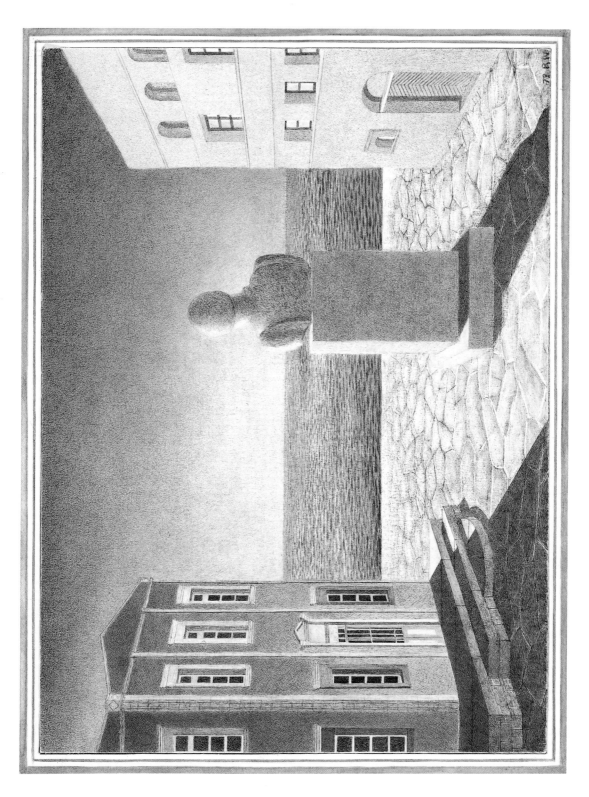

XIII

GRIKU
Drawing, pen and ink

· 250 x 170 MM ·

1 9 7 7

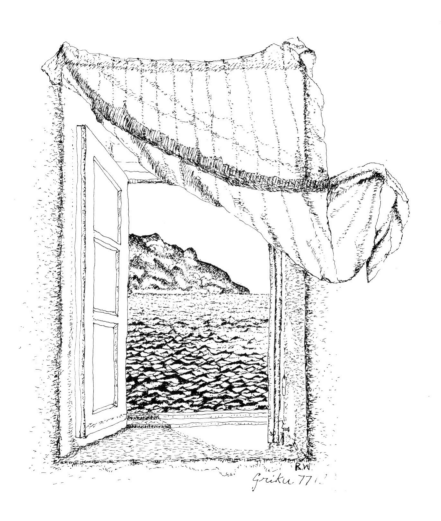

Grüku 77

XIV

NOCTURNAL VISITOR

· 300 x 260 MM ·

1 9 8 4 - 8 5

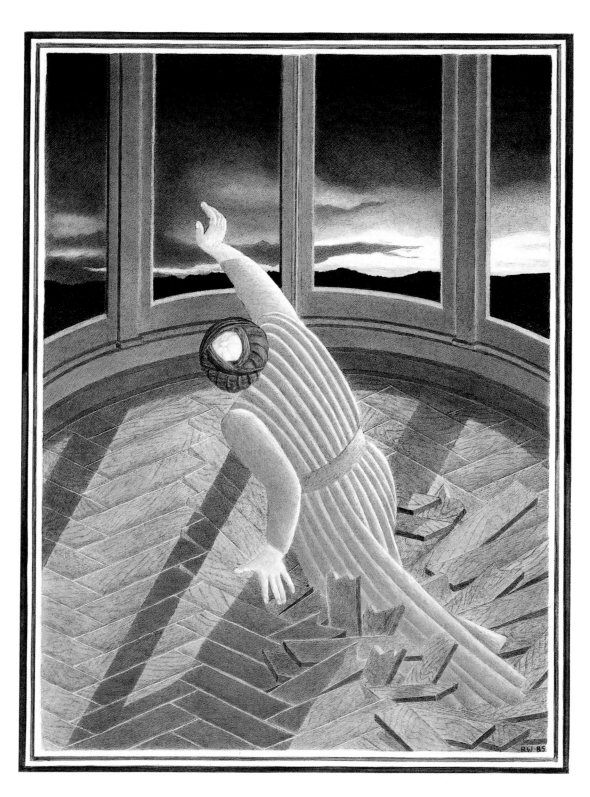

XV

DEMETRI'S DREAM

· 270 x 340 MM ·

1982

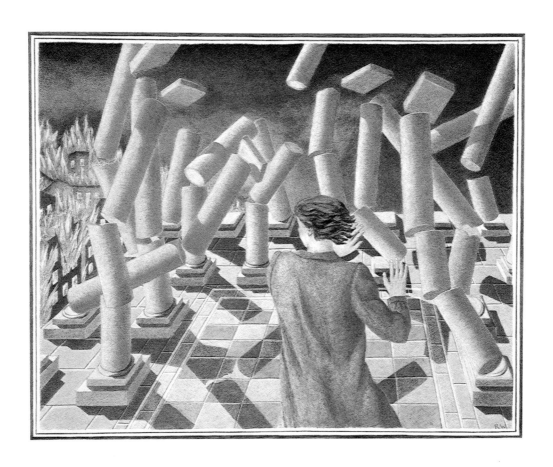

XVI

ANNE'S DREAM

· 230 x 310 MM ·

1981

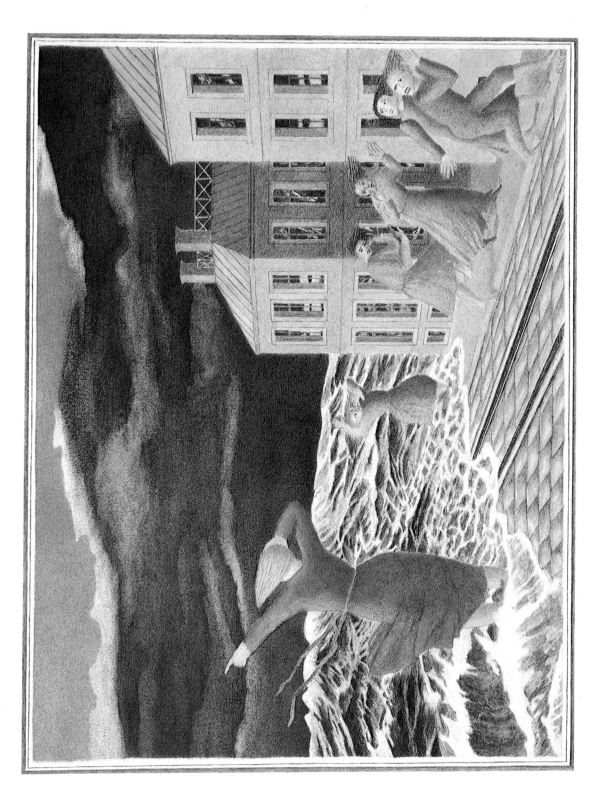

XVII

MY FATHER IN A DREAM
Drawing, pen and ink

· 135 x 140 MM ·

1 9 7 7

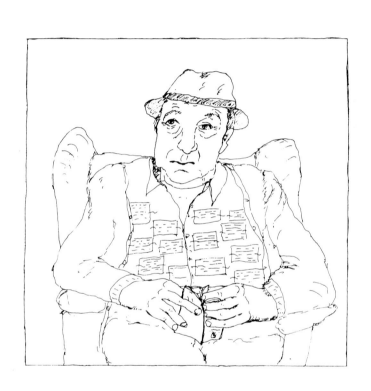

XVIII

LEO'S DREAM

· 260 x 180 MM ·

1 9 7 9

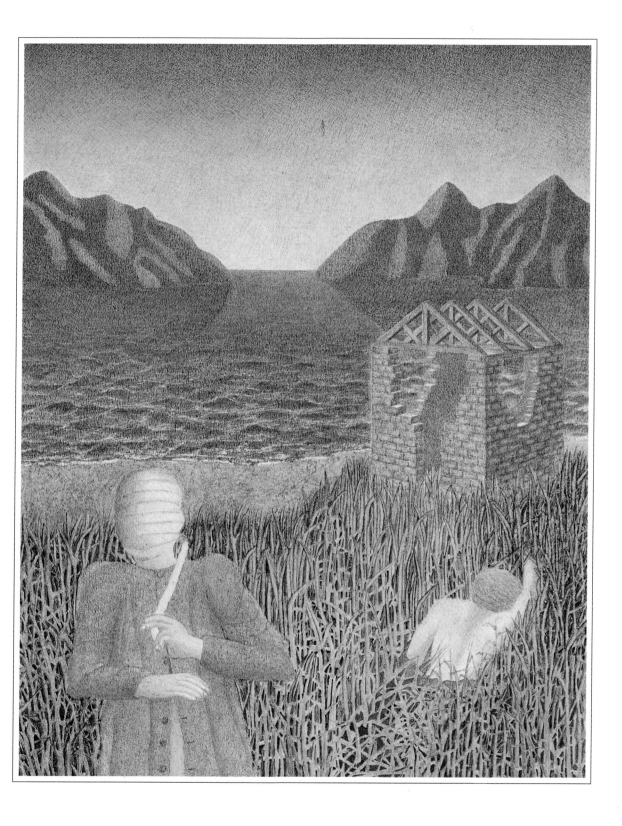

XIX

THE ARCHITECT'S DREAM

· 170 x 130 MM ·

1975

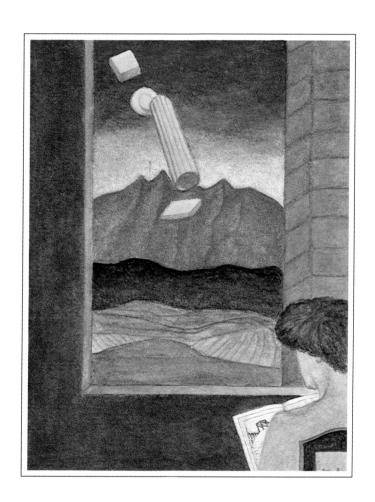

XX

LUXEMBOURG

· 210 x 210 MM ·

1984

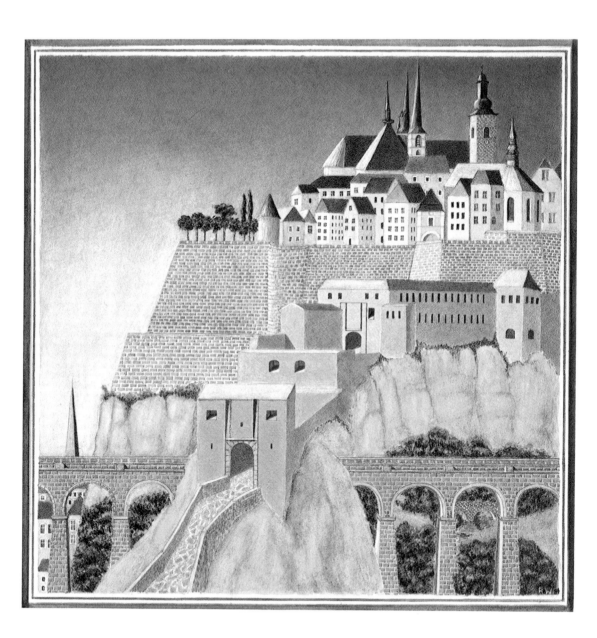

XXI

LANDSCAPE
Drawing, pen and ink

· 80 x 80 MM ·

1 9 7 7

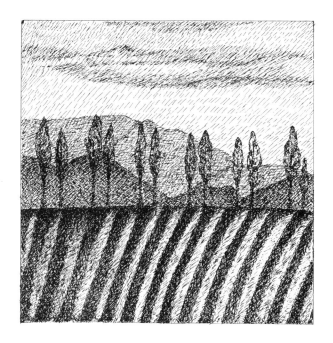

XXII

PUBLIC LOGGIA IN MAIN SQUARE

· 165 x 215 MM ·

1 9 7 7

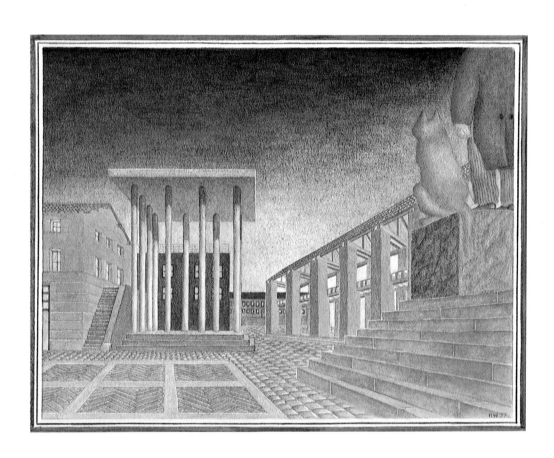

XXIII

TORTURE – A DREAM

· 287 x 337 MM ·

1985

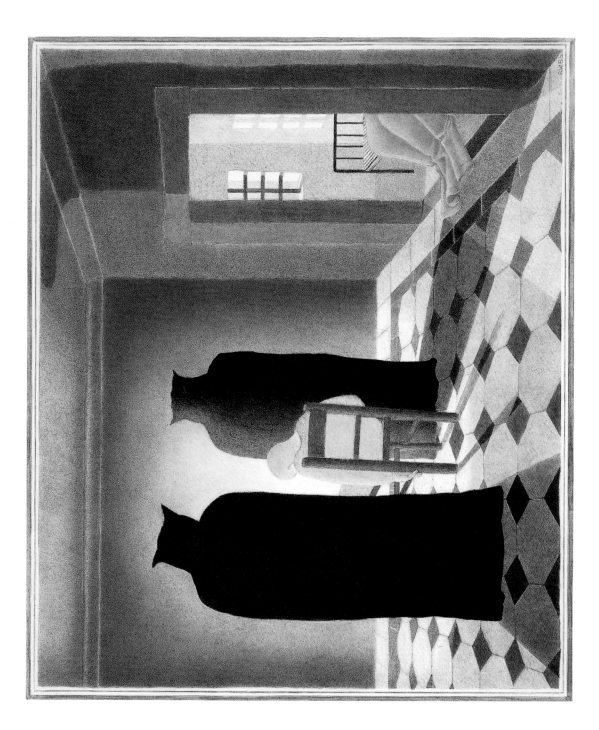

XXIV

WITNESSES FOR THE PROSECUTION

· 232 x 260 MM ·

1 9 8 4

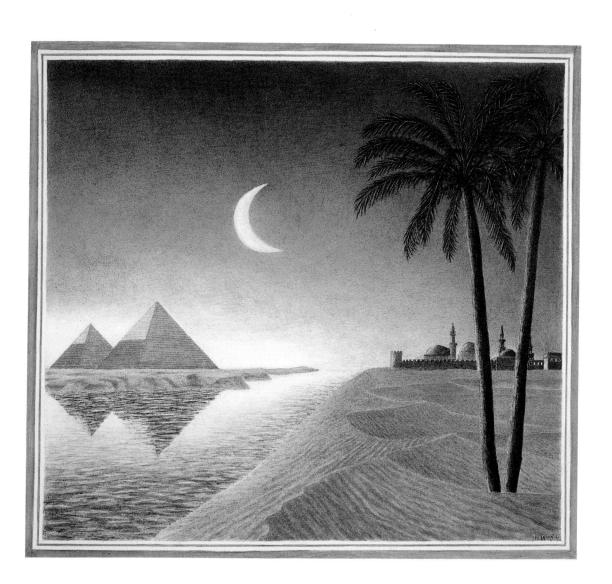

XXV

LANDSCAPE WITH BIRD

· 138 x 84 MM ·

1 9 7 5

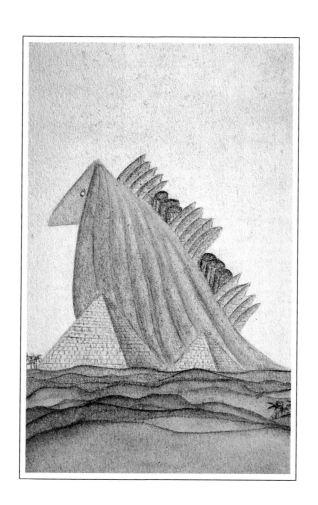

XXVI

KEN'S DREAM

· 190 x 240 MM ·

1979

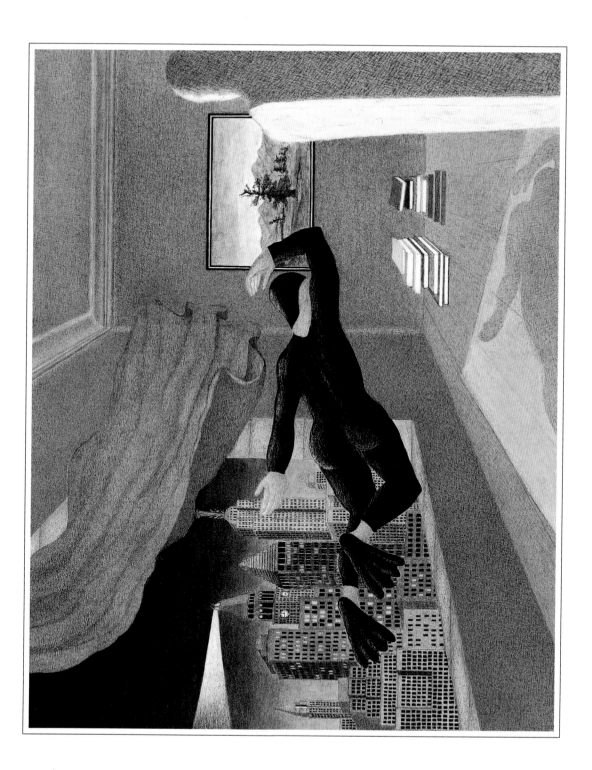

XXVII

SUNKEN LANDSCAPE

205 x 250 MM ·

1 9 8 1

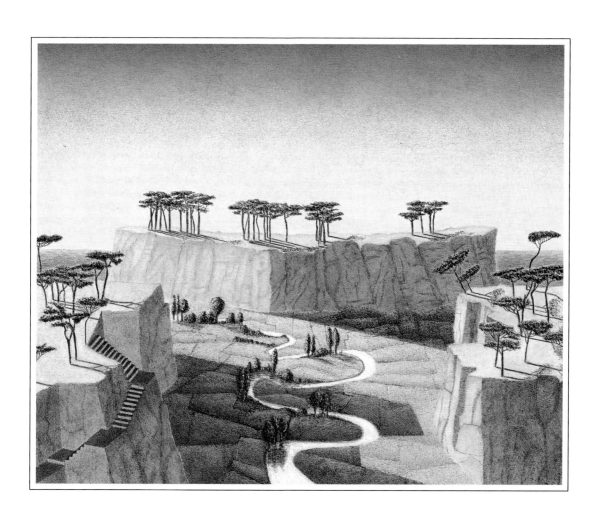

XXVIII

BREMEN MONUMENT

· 255 x 170 MM ·

1980

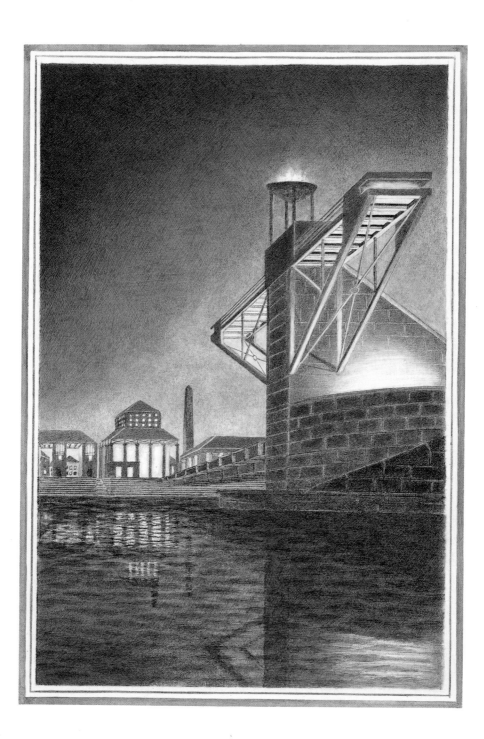

XXIX

LES FRÈRES ENNEMIS
Drawing, pen and ink

· 190 x 258 MM ·

1975

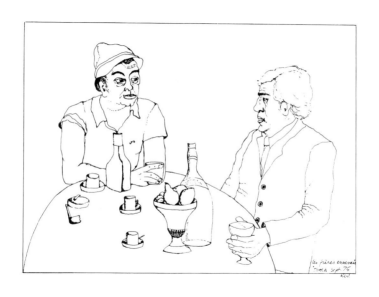

XXX

E V E N I N G F L I G H T

· 302 x 230 MM ·

1 9 8 5

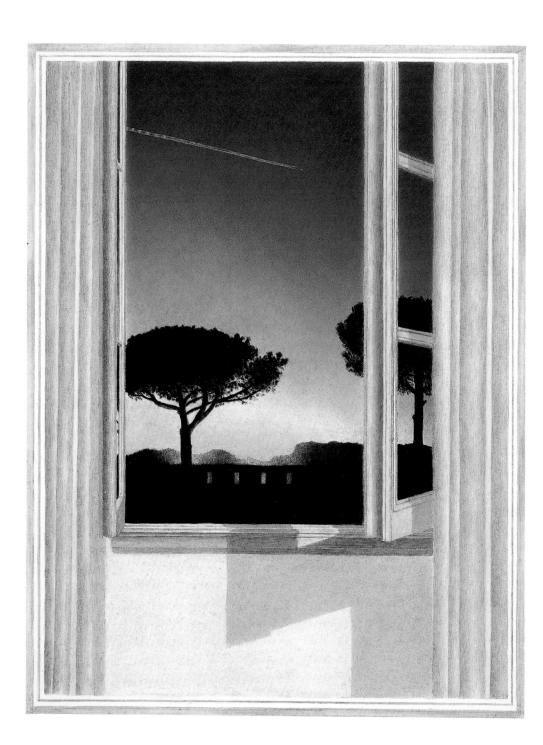

XXXI

FILADELFIA

· 200 x 142 MM ·

1983

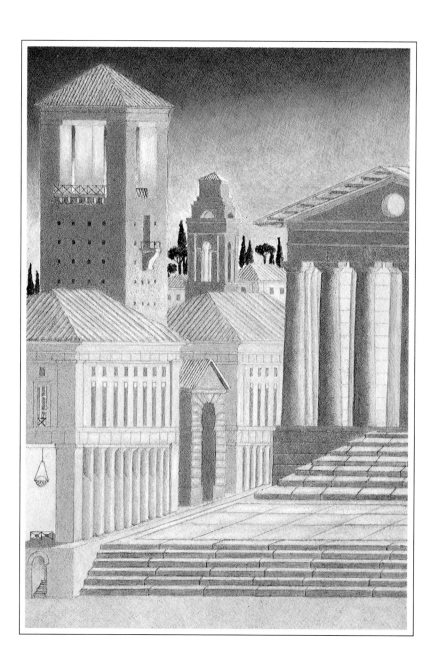

XXXII

NOCTURNE AT THE MARKET

· 210 x 180 MM ·

1 9 7 8

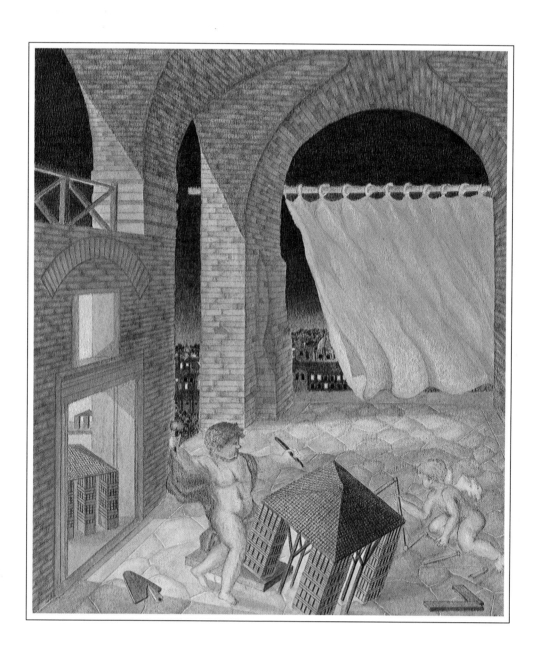

BIBLIOGRAPHY

PERIODICALS

Architectural Design 3/4, 1979, back cover
——. 5/6, 1982, pp. 2, 38–43
——. 5/6, 1984, cover and pp. 2, 3
——. 7/8, 1984, profile on Leon Krier, pp. 52, 53, 57, 60, 64, 95, 120
——. 11/12, 1984, cover
Architectural Journal, September 1984, cover
Archives d'Architecture Moderne (AAM), No. 14 (1978), cover; No. 20 (1981), cover; No. 21 (1981), cover; No. 22 (1982), cover; No. 25 (1983), cover; No. 26 (1984), cover; No. 27 (1984), back cover
A+U, November 1977
Casabella, December 1976, p. 28
City Limits, January 29–February 4 1982, p. 49
CNAC Magazine, March/April 1981, cover
Gran Bazaar, May 1983, pp. 206–209
Kunstforum 'Goldener Oktober', September 1983, p. 35
Lotus, June 1978, p. 20
Modo, October 1978, cover
Time Out, January 15–21 1982, p. 77

BOOKS, CATALOGUES AND POSTERS

Architecture Rationnelle (AAM), 1976, pp. 51, 115, 187, 193
'Bofill/Krier' Exhibition, Museum of Modern Art, New York, June 1985, catalogue p. 19
'Histoire, Archéologie et Création Urbaine', Reims, May 1985, poster for conference
'Images et Imaginaires de l'Architecture', Centre Pompidou, Paris, 1984, catalogue p. 370
Junge Architekten in Europa, Kohlhammer Verlag, Stuttgart, 1983, p. 97
Mir wölle bleiwe wât mir sin, cover for book on architecture in Luxembourg. To be published
'Places et Monuments', Institut Français d'Architecture, Paris, February 1984, cover of exhibition catalogue and poster
Illustration for catalogue and poster for UIA (International Union of Architects) Conference and Exhibition in Cairo, January 1985
'Villa Laurentina', Institut Français d'Architecture, Paris, May 1982, cover of exhibition catalogue; Freiburg/Breisgau, November 1982, poster

EXHIBITIONS

June 1980, Max Protetch Gallery, New York, group show
January–February 1981, House Gallery, London, group show
March–May 1984, 'Images et Imaginaires de l'Architecture', Centre Pompidou, Paris
August 1985, Open Exhibition, Royal Society of Painters in Watercolours, Bankside Gallery, London
June 1986, Graham Foundation, Chicago, one-man exhibition